RE_VISIONING BODIES Edited by Daniel Neugebauer, with contributions by Maaike Bleeker, Carmen Mörsch, Zeyno Pekünlü, and Eliza Steinbock

Re_Visioning Bodies

**Edited by
Daniel Neugebauer**

Contents

Re_Visioning Bodies

Invisible bodies cannot be read. The recalcitrant visuality of non-normative, othered, racialized, or other out-of-sight bodies therefore has little chance of inscribing itself in archives, narratives, or the "social subconscious." The alphabet of identities remains incomplete, the vocabulary patchy. Institutions such as archives, libraries, galleries, or museums are thus entrusted with an important task: the critical interrogation of content and method in the service of their social mission. The stories that bodies are able to tell—the assumptions, associations, or affects that are activated—have a lot to do with how they are archived. This brings in two key aspects that are explored in this volume: first of all, that archiving can be understood as a form of respect, of caring, of tenderness. It is a promise beyond death, a gift to future readers. The second aspect is the violence generated by the act of categorizing and the concomitant attribution of meaning. Indexing archival content using outdated or discriminatory vocabulary preserves the violence of that attribution, tying it to the archival object. Imposing expectations of social roles or a gender-specific appearance on the body through signs and symbols can also be violent. In order to circumvent both invisibility and violent attributions, the texts gathered here propose different kinds of *re_visions*: of one's own practice, of the bodily possibilities of knowledge production, and of the visual grammar of physical and social bodies.

Oh, that's me!

Eliza Steinbock opens the boxes and folders of Berlin's Lili Elbe Archive, a place of possibility for tens of thousands of queer and trans* biographies and stories that have so far rarely been told. A central feature for Steinbock is the tenderness with which archivists devote themselves to the drawings, photos, and snippets they have unearthed. This tenderness enables speculative reconstructions of communities, yielding an affective alphabet of queer and trans* histories. This is an urgent task, as visual archives of gender diversity are often full of violence themselves. The most famous example is probably Magnus Hirschfeld's Institute for Sexual Science, which was groundbreaking in its time, also for documenting sexual and gender diversity photographically. Despite their educational aim, these photos—with their

often dissecting, voyeuristic, and pathologizing style—shaped the image of such diversity as that of a medical curiosity. How can archival representation become more self-determined? How can archival neutrality be combined with activist affectivity?

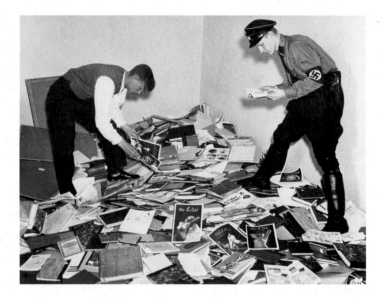

On May 6, 1933, students and Nazis raided Hirschfeld's Institute for Sexual Science, which was located on the premises of the present-day site of HKW in Berlin's Tiergarten. Large parts of the library and archive were destroyed in the process.

I know kung fu!

Neo's line from the movie *The Matrix* (1999) is certainly a provocation. He utters it after knowledge of kung fu is directly implanted into his brain and, from there, into his body. But what does he actually know? Knowing a lot about kung fu does not make him automatically capable of putting it into practice. Being a kung fu master would not automatically provide him with the cognitive knowledge of tradition, history, or muscular systems. He thus navigates between bodily knowledge and knowledge about the body. The process of uploading knowledge into his body is deliberately presented not only in a

technical and clean manner, but also as highly physical. How does a practice, an experiment, a dance, a repetition become an established part of our knowledge production? This question is explored by Maaike Bleeker when she employs the term *corporeal literacy*—a concept with a completely different connotation to Bonaventure Ndikung's *corpoliteracy*, presented in the *Counter_Readings of the Body* volume of this series. In brief, *corpoliteracy* defines the body as an archive and as a system of signs. It shows how an active and conscious use of body signs and body knowledge can lead to new insights as well as to conscious forgetting and unlearning. *Corporeal literacy*, by contrast, refers to the body's ability to develop new literacies or systems for producing meaning in order to learn with and through them and to expand its experience of the world.

Filtered and veiled

In an artistic self-experiment, Zeyno Pekünlü took on the role of bride—or rather, of four brides—in order to examine cultural constructions of bridal aesthetics in Turkey and the Balkans from a feminist perspective. Under the impression that they were dealing with a "real" bride, the stylists and photographers were left to make all the decisions concerning hairstyle, make-up, and pose. Ten years later, Pekünlü embarks on a revision of her work *Hairy Tale*, focusing on the "sign system bride." She examines the production conditions of this cultural figure, connecting the professional wedding photos with statements by the hair and make-up specialists who did her make-up in the different cities. From passion to rejection, the affective charge of passing remarks often reveals more than an official wedding vow. What happens when social ideals collide with romantic fantasies? In addition to ideas about gender stereotypes, fashion traditions, and hair and make-up skills, it is above all a virtuoso use of Photoshop that is essential to simulating the situation of an ideal bride and thus an ideal love for the souvenir photo. To what extent do the attitudes of beauty experts to marriage, life, and gender determine what the end-product bride will look like? And what kind of artificial world must be created by filters and image processing to make a bride recognizable as such? Pekünlü uses her own body to outline the phantom body of a bride, thus pointing to the complex social constructions of bridal semiotics.

The white spots of literacy

Just like archivists, art educators choreograph situations that correlate body, art, canon, and context. Carmen Mörsch analyzes this frame of reference from a self-critical perspective in which it becomes vital to situate art mediators themselves—who are not, or at least should not be, invisible, but rather tend to reproduce their own perspectives or privileges in their work. In her search for a power-critical documentation of art education, the author relies on a consistent and ongoing self-questioning of her own practice. With the help of *Critical Diversity Literacy*, she exemplifies how "white spaces" can be identified, changed, and colored according to the tenets of discrimination critique. The world-making quality of critical art education thus subtly moves into the center of knowledge production in the mostly white institutions.

All of the strategies presented here invest in time, and time can be translated as caring: At the very least, it's the moment it takes Neo to learn kung fu via data cables. Such rapidly absorbed knowledge appeals to the desires of a digital-knowledge society. But can the time it takes to develop a cultural technique be minimized? How much time does a bride need for her hairstyle? What is the lifespan of normalized, internalized, and perpetuated femininity? Can time inscribe itself into archival collections as crystalline knowledge, or as affective adjunct? Can time be inscribed in the moments it takes to read—with a critical tenderness—the contributions in this book?

Daniel Neugebauer
Translated from the German by Kevin Kennedy

Eliza Steinbock

t4t: Archival Legacies of Trans for Trans Adoration

I love scrolling through the sweetness that is #t4t pictures. My eyes teary, chest full, the sense of something about myself—hard to articulate but still felt—being shared across distances. #t4t arrives via Craigslist, Tumblr, and via very long Twitter threads where couples, throuples, and polycules upload themselves posing cheek to cheek or arm in arm or in those awkward selfies where one is kissing the other while trying to take the shot. Unlike most images of love, desire, and relationships that populate our online connected worlds, these t4t shared images (of amateur quality at best) are composed of all trans folks. That's right, *trans for trans* lovers. The shorthand comes from the digital language of hookup message boards and software applications—this kind looking for this kind—but has been embraced more widely in the digital intimacies of social media platforms and now adorns badges and T-shirts and even books. As the coeditors of the journal *Transgender Studies Quarterly*, Cameron Awkward-Rich and Hil Malatino, write, "anecdotally, it seems, many of us [trans folks] are 't4t,'" a still undertheorized descriptor that they offer to name circuits of desire and trans attraction as well as practices of trans solidarity and mutual aid.[1]

Signaled in the phrase "nonce taxonomy" from Eve Sedgwick, this making, unmaking, and remaking of categories in order to navigate the social world, in this case from hookup board to signifier of support and love, is a fabulously proliferative process in the digital age.[2] The crucial point of a nonce word coined for short-term use is that the meaning is resistant to being grasped by outsiders, which is to say meaning derives from a sense of "emic" insidership that attends to the internal elements of a culture, a form of knowledge production that generates its own system of representation to push back on

1 Cameron Awkward-Rich and Hil Malatino, *TSQ: Transgender Studies Quarterly*, vol. 9, no. 1: The t4t issue (2020), Institute for LGBT Studies at the University of Arizona, https://lgbt.arizona.edu/transgender-studies-quarterly, accessed February 2, 2021.
2 Eve Sedgwick, *Epistemology of the Closet*. Berkeley, CA: University of California Press, 1990, pp. 22–23.

dominant paradigms of sensemaking that would occlude it or gloss it with the taint of negativity. It has been the case with sexual and gender subcultures more generally: Naming invokes and breathes into being an embodied social self, however unintelligible such language, words, or acronyms like t4t may be to broader populations.

"t4t," then, seems to signal a new vocabulary made up of a scrambling of sex–gender–sexuality alphabets, pressing them into new configurations. Acknowledging the changing meanings and inflections of various "transgender" identities, historian Susan Stryker has parsed that she uses the word trans "to refer to people who move away from the gender they were assigned at birth, people who cross over (*trans-*) the boundaries constructed by their culture to define and contain that gender."[3] The ways and means for desire to move away from a bounded notion of gender may not be keyed directly into what passes for "commonsense sexuality," that is, the behaviors, practices, and fantasies typically attached to sex. But, and again more anecdotally than properly theorized, many trans people (vociferously Kate Bornstein, Mira Bellwether, and Buck Angel, among others) have shared that their desire to transition was integrated with the desire to have sex in a differently configured and contoured body.[4] Perhaps t4t, therefore, describes this desire to have sex in a differently configured and contoured body with another person who likewise shares an altered body. But I would not want to fall into the trap of limiting the notion of trans *for* trans to this commonsense notion of sexuality; so, to echo Awkward-Rich and Malatino, I expand my investigation and include visualized practices of trans adoration more generally. With a genealogical approach, in this essay I wish to cast my gaze backwards to examine this dilated form of trans for trans in the "old media" formats of the photographs,

3 Susan Stryker, *Transgender History*, 1st ed. Berkeley, CA: Seal Press, 2008, p. 1.
4 See Kate Bornstein, *Gender Outlaw: On Men, Women, and the Rest of Us*. New York: Routledge, 1994; Mira Bellwether, *Fucking Trans Women: A Zine About the Sex lives of Trans Women*, http://fuckingtranswomen.org/, accessed February 2, 2021; and the documentary film directed by Dan Hunt, *Mr. Angel*. US: Pearl Wolf Productions, 2013.

drawings, and scrapbooks that one can find in archival holdings and which comprise that most precious project of personal collecting.[5]

Archival Gifts

Firstly, there are affective continuities, a web of sentiments that underlie fan- and popular cultures as well as personal archiving. The Internet is the largest archive in history, and as many have noted, there are more digital data points per person than ever before. But in the paper or non-digital version of scrolling, unpacking, unbundling, and getting my hands on materials in on-site archives, I can attest to the same kind of experiences as those I've had on Twitter. Becoming teary, chest trembling, something catching in my throat. A sense of falling into a gauzy space that blurs out the windows, the scratched tables, the dusty boxes. In these moments, what I can only call the shakiness of recognition clicks into place: I know myself to be a historical subject, because somewhere, someone else like me existed. As Malatino says about his experience in archives and being with Claude Cahun's photography: "Cahun's work—and so many other archival traces of trans, intersex, and gender nonconforming lives—feels like a gift that I'm still figuring out how to use. All I know for sure is that it sparks a sense of connection that resonates even as it remains opaque. It makes me feel some kind of way: less alone."[6] I know that this person and I are not the same; the encounters with these images are not about me having a moment of identification in the sense of "oh! that is me." But they are something like me.

Like Malatino, Jules Gill-Peterson, Harrison Apple, Abram Lewis, Elspeth Brown, Syrus Marcus Ware, and other trans-studies

5 For analysis of collecting practices in paper and digital forms, see Katie Day Good, "From Scrapbook to Facebook: A History of Personal / Media Assemblage and Archives," *New Media & Society*, vol.15, no.4 (2013), pp.557–73.

6 Hil Malatino, "Something Other than Trancestors: Hirstory Lessons," in *Trans Care*. Minneapolis, MN: University of Minnesota Press, 2020, https://manifold.umn.edu/read/trans-care/section/3f4b5252-c142-4c51 -88f2-5d67a43607f2#node-8aee787b606ed21673e3236f24692fd57e f0594e>, accessed February 2, 2021.

peers whose work on trans archival studies is shifting the field, I too ask, how will I write about them, to them, for them, with them, in a way that does justice to their lives and to our times?[7] So many of us go in search of people like ourselves, and this expresses a form of self-love that is also the answer to a desire and regard for others like us.[8] Acknowledging the problems thrown up by local, dated language when thinking across geographies and temporalities, like anachronism and incommensurability, Stryker articulates trans history not as a history of transgender people, but as history read through the perspective of trans people, who are thus able to explain what we recognize as "transiness."[9] Herein, I want to add that this collecting, preserving, searching, and interpretative work has the desire structure of trans for trans: of being "for" and on the side of transness, and also with a desiring for transiness. The justification of historical accuracy—showing that our people have lived, have gathered, fucked, and loved—would be enough, but from within a t4t model, we can further learn how to work these counter-archival bits of tacit, embodied

7 See ibid. Also see Jules Gill-Peterson, *Histories of the Transgender Child*. Minneapolis, MN: University of Minnesota Press, 2018; Harrison Apple, "The $10,000 Woman: Trans Artifacts in the Pittsburgh Queer History Project Archive," *TSQ: Transgender Studies Quarterly*, vol. 2, no. 4 (2015), pp. 553–64; Abram J. Lewis, "'I'm 64 and Paul McCartney Doesn't Care': The Haunting of the Transgender Archive and the Challenges of Queer History," *Radical History Review*, vol. 120 (October 2014), pp. 13–34; Elspeth Brown, "Archival Activism, Symbolic Annihilation, and the LGBTQ+ Community Archive," *Archivaria*, vol. 89 (Spring 2020), pp. 6–33; and Syrus Marcus Ware, "All Power to All People?: Black LGBTTI2QQ Activism, Remembrance, and Archiving in Toronto," *TSQ: Transgender Studies Quarterly*, vol. 4, no. 2 (2017), pp. 170–80.

8 See the podcast by Morgan M. Page, *One from the Vaults*, SoundCloud (posted 2016–21), https://soundcloud.com/onefromthevaultspodcast; and the opening panel contribution by Morgan M. Page, "Trans Collections Guide Launch, December 3, 2020" [video], YouTube (posted December 16, 2020), hosted by Elspeth Brown, 6:40–12:50 min, https://dhn.utoronto.ca/trans-collections-guide-launch-december-3-2020/, both accessed February 2, 2021.

9 Susan Stryker, "Panelist Response in Trans Collections Guide Launch," 1:31:26–1:33:00 min. See also Stryker, *Transgender History*; and Susan Stryker, *Transgender History: The Roots of Today's Revolution*, 2nd ed. Berkeley, CA: Seal Press, 2017.

knowledge that resist the traditional archive's presumption of static and binary forms of sex, gender, and sexual identity.

In predicating this reading on my desire, my search for historical subjectivity, and the sense of dating with my precursors, I want to transform the archive's typically discursive register regarding trans life, mottled as it is with medical jargon and pathologies, into a visual register of mini-pornographies. In doing so, I hope to represent the visual grammar of bodies that figure themselves into a refusal to be erased, that in some moment of photographing and scrapbooking said *look at me*, and *I promise to look at you*. As trans*, non-binary, gender nonconforming folks, we are not meant to look at each other from a transloving point of view, but to frame ourselves always within the cisgender gaze that judges us faulty or lacking. To reciprocate a look at one another, to gather in an acknowledged mutuality, is to claim a political subjectivity and collective affinity.

The Trans Look for Transiness

In writing here, "I want to claim the right to look," I echo Nicholas Mirzoeff, but in my trans tongue; I too bring it to the "personal level with the look into someone's eyes to express friendship, solidarity, or love."[10] Expanding our communities beyond the directly interpersonal space of the here and now, might we look into the eyes of someone with a drawn womanly form, or with a bearded face depicted on a creased snapshot? Mirzoeff says this look must be mutual and somehow exclusive or unreadable to the outside: each inventing the other, or it fails.[11] However, Jacques Derrida's original coinage of the phrase "the right to look" was published in collaboration with Marie-Françoise Plissart, together with her photo-essay on lesbian desire that was meant as a series of images for others to see and with which one can triangulate their subjective desire (perhaps standing in for the photographer).[12] This example of a knowing materialization and pres-

10 Nicholas Mirzoeff, "The Right to Look," *Critical Inquiry*, vol. 37, no. 3 (2011), pp. 473–96, here p. 473.
11 Ibid.
12 Ibid., where f. n. 2 explains that this comes from Jacques Derrida and Marie-Françoise Plissart, *Droit de regards*. Paris: Les Éditions De Minuit, 1985, p. xxxvi.

ervation into photographic form teases an open number of future lookers into their wayward gazing. Queer, sissy, femme, stone, queen... The practice of claiming the right to look, then, rearranges the markers for the visible/seeable in an era; it asserts autonomy within a feudalistic gaze system; it confronts the authorities that would cordon off such bodies and scenes from being worthy of being looked at, or looked in on, without the proper credentials. Though the act of taking the right to look might be unrepresentable, the affective mode of regard of t4t transloving might well carry weight through the poetics of feeling expressed in the depiction and description of it. I venture that t4t adoration announces itself on the granular level of blushes and prickles keyed into the experience of looking. Hereby, I invite you to look with me, and with this claim in mind, listen to my descriptions (as breathy as they may be), and know that I too promise to look at you.

Proxies in Looking: A Note on Method

First a caveat: In preparing this essay on the practice of trans adoration within archival spaces, I had big plans to spend time exploring the image holdings of the Lili Elbe Archive in Berlin. Unfortunately, the outbreak of the global COVID-19 pandemic kept me from making the trip in person. No chance then of my hands roving over the boxes, prints, and photographed cheeks. Fortunately, the Lili Elbe Archive, founded in 2013 as one of the biggest archival sources in Europe for trans materials, participates in the hub of the Digital Transgender Archive, with sixty-one items hosted there and made open access.[13] But my online search only made me more curious about the thousands of other potential finds; I wanted to see what might come from fumbling around in the proverbial darkroom, searching for a lover unknown in advance. I needed a proxy who could, with some directive from me, enter the jumble.

Through his personal contact with the director of the archive —the amazing Niki Trauthwein—I charged Daniel Neugebauer, a queer professional with a casual drag queening habit who is the

13 See the Lili Elbe Digital Archive, http://www.lili-elbe-archive.org/, and "Lili-Elbe-Archive Inter*Trans*Queer History," The Digital Transgender Archive, https://www.digitaltransgenderarchive.net/inst/kd17cs89j, both accessed February 2, 2021.

commissioning editor of this essay, to be my surrogate for this desire line. He visited the archive in a private flat in Neukölln, consisting currently of one very large, overstuffed room with floor-to-ceiling archival cabinets. I told Daniel:

> I'd love to see drawings, illustrations, paintings, photographs in which a friendly or sexual desire is cultivated between and amongst trans people. This could be overtly sexy, or even sentimental as in honoring our elders (like this painting: https:// www.digitaltransgenderarchive.net/files/w3763676r). I'd love to see group shots/portraits, couples, doubles, thruples, solo, or anything that you would see as being non-stigmatizing (thus not mug shots or medical photography).[14]

The result was incredible: I learned that a huge percentage of the holdings were in some way concerned with sex in the sense of being sexually explicit, (partial) nudes, or erotically posed. This included copies of *Revue*, a naked *Stern* magazine cover, books documenting cabaret stars, and the contact pages of transvestite and transsexual magazines. Daniel also explained what he learned from Niki: that the archive mainly consisted of personal collections posthumously given to be archived. In these boxes, he found many self-designed photo and image albums with additional comments. These he thought particularly touching because they were filled with personal notes, doodles, even stickers. This gave us the idea of arranging the essay as a series of my own personal notes on the images that he and Niki pulled together on my directive and which I then sorted, selecting a few to present under the aegis of my own t4t mini-scrapbook.

In order to narrow down the search on his second journey to the archive, I asked Daniel to focus on materials that were not overtly mainstream porn or from fetish magazines, but that spoke to desire, loving, care, and touch. Of the over fifty documented images, I selected five that tickled the notion of t4t: These include snaps from a party and a personal gathering, publicity photographs of famous trans women, an anonymous pencil drawing, and also pictures that have been contextualized in history through scrapbooking. The fact that

14 Email from Eliza Steinbock to Daniel Neugebauer, August 10, 2020.

trans subjects are mostly shelved in medical and police archives and not regularly included on their own terms in queer archives, mean that these materials suggest a method of counter-archiving. That the collectors are trans folks, not a certain Dr Kinsey or Dr Hirschfeld, lends the materials a particularly poignant sheen. They make me reflect on the questions: What is *our* starting place? How do these images trace a different genealogy and timeline of our origin story of activist moments that center affection and love for each other? Or, how do they evidence a counter-visuality, for each other and not for public consumption in general?

My general aim was to gather materials from the archive as my basis to rethink trans for trans discussions historically and to thereby impress upon readers that it is not a new movement or a hashtag trend but an enduring non-binary grammar of desire, spoken in different accents and with room for invention. In this regard, this essay continues from the work of my book *Shimmering Images: Trans Cinema, Embodiment, and the Aesthetics of Change* (2019) that opens with the consideration of the identity term "translover." I use the term for myself as a commonsense sexuality descriptor, but also as a theorist who tries to decipher visual grammars of desire in cinema that dance around "the fascism of language."[15] This phrase is from Roland Barthes, queer extraordinaire who personally knew the violence of binary paradigms that undercut genders, sexualities, and sexes. In his research lectures on the Neutral, he sought out figures, traits, and moves that outplayed the operative binary language paradigm of meaning—that is, something is signified by this, because it is not signified by that.[16] He identified the androgyne and the shimmer as well as other visual traits like greyscale that require reading for nuance; this assortment gave me the encouragement I needed to link together visual reading with expansive, affective, but precise non-binary gender readings. In turning to the archival images now, let us claim the right to look, the trans look, and resist for a moment the fascist violence of binary paradigms. With "a look of love," as Dusty Springfield sang in 1967, let's embrace the tenderness and gifts from the past that make us feel some kind of way: less alone.

15 Roland Barthes, *The Neutral: Lecture Course at the College de France (1977–1978)*, trans. Rosalind Krauss and Denis Hollier. New York: Columbia University Press, 2002, p. 42.

16 Ibid., p. 7.

Queer dance pair at the Miss Travestiti event in Turin, Italy, 1970.

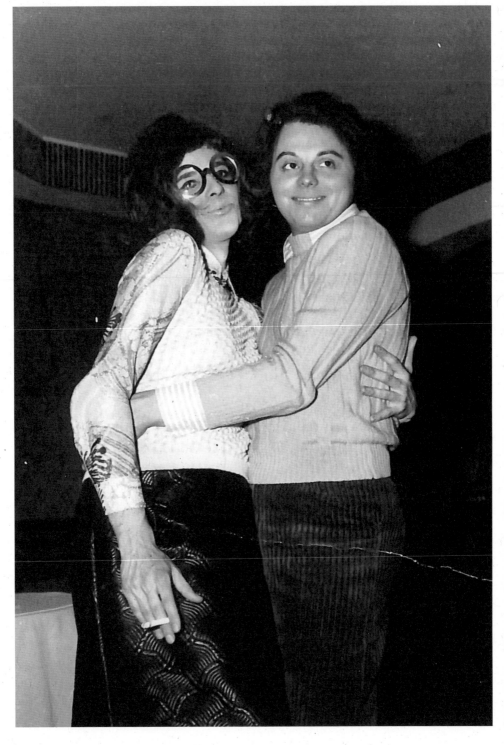

t4t, above all else, counters the overwhelming trope of the wretched, lonely trans person, depressed and suffering. t4t says, "you are not alone, not in your transness, nor in your personhood." I love the ease with which these people in the image on the preceding page embrace. With lips pursed towards the photographer, the woman on the left seems to pause for a moment from her slow dance—and from her recently lit cigarette. I'm struck by the shape of their faces, the relaxed grin of the man. The caption from the archive tells me that this is a pair of dancers from an event in Italy, Miss Travestiti, at a time when the law forbade wearing cross-sex clothing in public. This image captures a moment of joy, shared amongst an intimate public. I feel both the sensation of the clasped hands around the waist and the kiss directed outwards; I'm oscillating between the positions within this trio.

In her article on the photographic collection of self-described gay, femme, South African hairdresser and dancer Kewpie, which largely takes place in Cape Town's District Six during apartheid, Ruth Ramsden-Karelse highlights the creative function of the images as generating a space to move within for Kewpie and her girlfriends.[17] Though these images are usually shown as documentary evidence of an accepting space of a multiracial neighborhood, Ramsden-Karelse listens carefully to the conflicting messages in Kewpie's interviews about District Six being constrictive and accepting, violent and embracing. This—combined with the titling of the images as Germany, Paris, or New York and their subjects as Golden-era Hollywood stars—provides a convincing framework for seeing the photographic practice as a means to move around under apartheid racial laws, to move away from South African points of reference, and to shift the imaginary horizon of being. Though I'm not examining this anonymous collection of images from Turin in the Lili Elbe Archive as a whole, I think a similar kind of dual-reading is warranted, one that considers the creative rather than solely the documentary meaning of the image for trans folks.

The existence of this picture of a dance pair at a trans-inclusive event may well tell us that trans people gathered together despite

17 Ruth Ramsden-Karelse, "Moving and Moved: Reading Kewpie's District Six," *GLQ: A Journal of Gay and Lesbian Studies*, vol. 26, no. 3 (2020), pp. 405–38.

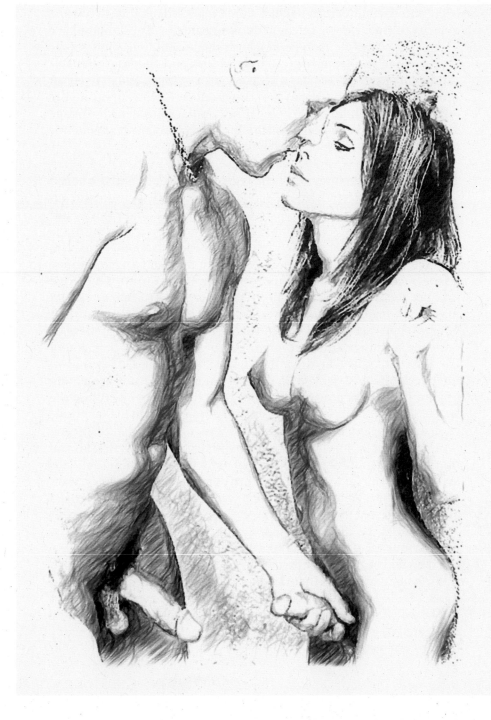

legal and social decrees against doing so. Perhaps this shows the tenacity of trans people or could demonstrate that Turin might have been more accepting than previously thought. But I'm caught by the crease along the lower right-hand side, and in thinking that this candid image could also have been a source of joy in and of itself for the collector who lived beyond this period. Gazing upon it, I'm reminded of the lightness of being together that re-viewing the image allows me access to, especially in this historical moment of a pandemic that has made the ease of touch impossible.

The drawing on the previous page is also about touch and the desire to be together, except here the scene is not a smallish, intimate public, but what feels like a very personal contemplation towards cultivating and even generating this fantasy. Perhaps it is a drawing made from a photograph, a pornographic film still, or from memory. I'm distracted by the detailed work on the man's necklace, whose roped chain is carefully rendered, more so than his scrotum. The movement of the woman's hair is life-like, whereas her arms disappear into the thin paper. Does this attention to the upper parts of their bodies suggest a certain romanticism? Or that the artist had more experience learning to draw other aspects of human forms than genitalia? I cannot know who drew this, but I can wonder: Did they want their cock tenderly stroked, or to reach for a soft girlcock? The point of identification is not so clear, with both bodies equally filling the space and set along the same axis of foreground. This aesthetic choice makes both positions desirous. It seems to me that this scene is rather about being within it, within the stirrings of lust that fill and lift the bodies, producing tumescence. And yet, as the main action is a hand reaching for a body that in turn offers itself up for a kiss, I venture that it speaks to wanting to be wanted, desiring to be desired, and on one's own terms.

Though the image likely does not depict two trans-identified people, it does at least speak to a combination of translovers that is often reviled by cisgender men who wrongly assume that desire for a trans woman indicates that they harbor homosexual feelings. As so much sexual fantasy content containing trans women is created by and largely for cisgender people, this "humiliating" element of being castigated as gay might be one point of attraction. But, this drawing has not one hint of shame: These are lovers exploring each other

tenderly. A deep sense of vulnerability suffuses the way they barely touch. It is this tenderness that grabs hold of me and reminds me that this might be what some viewers look for in the trans pornographic imaginary. Laura Horak has noted that since the 1980s, commercial pornography has been "one of the few places to regularly represent trans women, frame trans women as subjects and objects of desire," and while these performers tend to be busty white non-op blondes, they are at least finding employment that inserts them into a sexual script.[18] I feel this erotic drawing is likely created by someone who knows the hypersexualized, stigmatizing trope of the tranny slut depicted in porn, but has chosen to counter this dominant form of visualizing trans women's sexuality with an image of a woman who knows what she wants, and what her lover wants, but takes her time. This is not the frenzied moment of climax, but the drawn-out longing, the teasing even, of lovers exploring one another's still tenuous, perhaps anonymous, connection.

Sharon Cohen was born February 2, 1969, making her twenty-nine years old when she performed the song "Diva" under her professional pop-star name Dana International, as the Israeli contestant for the Eurovision Song Contest in 1998. This was her second try (the first being in 1995), and although she already had gold-certified hits in Israel, with her overwhelming win for "Diva," she became a household name and a bright, shining star across the European continent. Personally, since 2002 living in Amsterdam, I have enthusiastically danced to her crisp, energetic voice singing in Hebrew about Aphrodite and Cleopatra, with no idea who she was or the history of the song. Unbeknownst to me until recently, Dana International shifted the discourse on trans people, especially for women, in the Dutch news media. In a deep dive into the representation of transgender people in the Dutch media from 1991 to 2016, Mariecke van den Berg and Mir Marinus showed that familiarity and the love of a celebrity can instigate new ways of framing trans experience.[19] Case in point:

18 Laura Horak, "Curating Trans Erotic Imaginaries," *TSQ: Transgender Studies Quarterly*, vol. 7, no. 2 (2020), pp. 274–87, here p. 277.
19 Mariecke van den Berg and Mir Marinus, "Transcripts: The Representation of Transgender People in the Media in the Netherlands (1991–2016)," *Tijdschrift voor Genderstudies*, vol. 20, no. 4 (2017), pp. 379–97.

Press photo of Dana International, May 10, 1998.

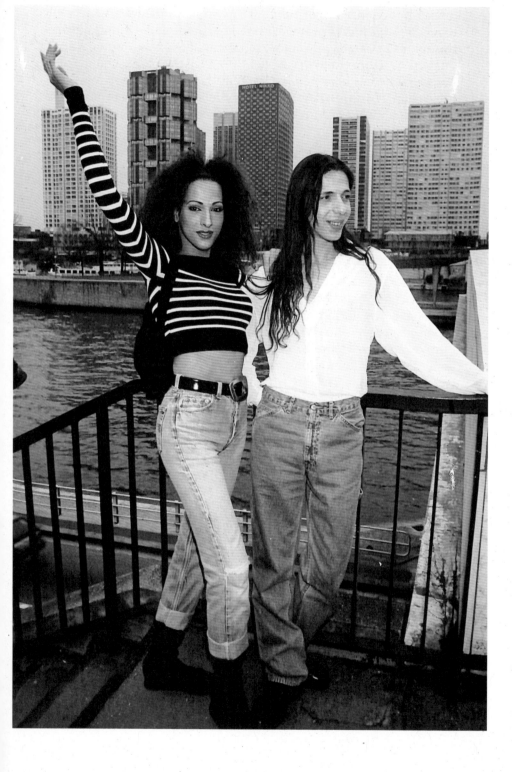

After Dana International released "Diva" as a single in Europe, it reached the top ten in the Netherlands (also in Sweden, Belgium, Finland, Ireland, and number eleven in the UK charts).[20] Her popularity as a singer led to extensive requests for interviews, which van den Berg and Marinus have studied in the Dutch context via their appearance in print news media. The most exploited and open fact about the singer was that she underwent "sex reassignment surgery" in 1993. Difficult to read and watch now, the fascination with her curvaceous body, with her full lips and incredible diva-like vocal ability on full display: She was a spectacle of "can you believe it" femininity. Yet, as van den Berg and Marinus point out, her openness as a trans person and her celebrity status challenged the previously popular script attached to trans women: Often ignoring the role of the perpetrator, reporting focused on instances of discrimination, physical violence, name-calling, and murder that put the trans woman in the role of the "victim," emphasizing vulnerabilities, and effectively erasing any sense of agency on the part of the trans person.[21] The spectacle of violence, then, is replaced by the spectacle of success: the superhuman qualities of the strong, skilled, and sexy trans woman.

But this picture of Dana International shows us an image of a worldly Sharon who leans on the shoulder of a friend, who I read as another trans woman. There is a sense here that she made it because there was a circle of friends behind her, a community that raised her during her more than a decade of working as a drag queen performer, singing her lungs out in Israeli clubs. Who would we be without our friends? Who gives us the courage to live our lives, out and proud, arm raised in a gesture of hard-won arrival? It seems slightly informal for a press photograph to me, depicting a girl at ease with herself, yes triumphant, but hardly a polished glamour shot that typically accompanies news articles. Of those 100 million viewers who witnessed her win, I think of all the trans folks who saw her as one of their own, that perhaps they too felt deserving of praise, their talent recognized, in receipt of applause. This picture reminds me that we can't do it on our own. We all need each other; we need to lift each other up.

20 Anonymous, "Dana International," Wikipedia (undated), https://en.wiki pedia.org/wiki/Dana_International, accessed February 2, 2021.

21 Ibid., van den Berg and Marinus, "Transcripts," p. 388.

Daniel found the scrapbooks of German trans pioneer Gert-Christian Südel and enthusiastically told me about their touching composition, depicted here. As a trans man active within the political arena who was fighting to achieve legal status for his fellow transsexuals (and won!), Gert-Christian was famous in his own right. Niki Trauthwein has published a biography titled *Peter Pan in Hamburg* on Gert-Christian's life as a pioneer, activist, and survivor; for German readers this is a must-read for an understanding of the stakes of his campaign and the importance of trans masculine leaders and thinkers, and of trans men lovers, in our history.[22] Fueling his mission to improve the lives of trans people, I imagine, was the love he felt for them. These two pages from his personal scrapbook—dedicated to cabaret star Romy Haag (from the Netherlands) and performer Angie Stardust (from the United States), who both settled in Germany in the mid-1970s—indicates that he was also a massive fan and lover of trans women. This kind of t4t relationship between trans men and women has had little coverage, although it's growing. I'm reminded of the gorgeously intimate and experimental photographic project *Relationship* (2008–13) by Zackary Drucker and Rhys Ernst, which was exhibited in the Whitney Museum Biennial in 2014 and published as a monograph in 2016. Of the things I can think of, it comes closest to this scrapbook-like quality of preserving meaningful fragments, moments, mementos, and messages.[23] As visual artists, Drucker and Ernst gravitated towards documenting their relationship, which was also a period in which they were both physically transitioning, at first not intending it to become a showcased artwork. Yet, the photography does more than the usual time-lapse documentation of change; it offers a wry and sometimes melancholic, but more often exhilarated, commentary on sharing an experience of volatile gendered becoming.

Where *Relationship* says "I see you seeing me, and I see us," the exchange of looks between Gert-Christian and his loves is more unidirectional. In one snapshot: The blond Gert-Christian wears a

22 Niki Trauthwein, *Peter Pan in Hamburg. Gert-Christian Südel: Transpionier, Aktivist und Überlebenskünstler*. Münster: LIT Verlag, 2020.
23 Zackary Drucker and Rhys Ernst, *Relationship*. Munich: Prestel, 2016.

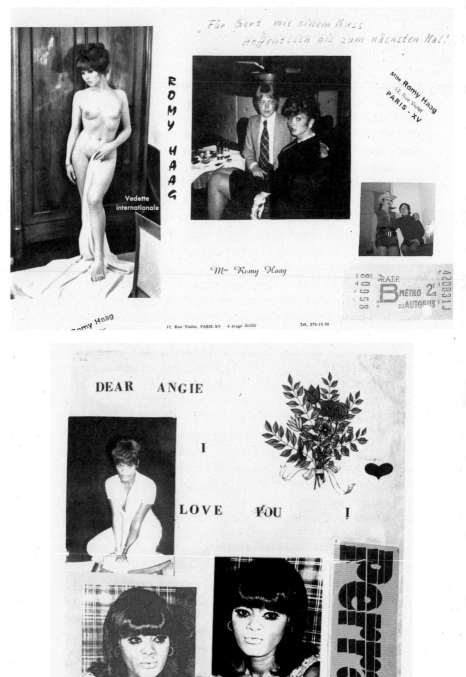

bold red tie and places his arm around Romy, his hand on her thigh, eyes locked into her made-up face. Romy looks over to the photographer, who seems to have stolen this shot at the same moment that Gert-Christian steals his full-on look at her. Romy, clothed in a sexy black cocktail dress, is doubled by the crème skin of the Romy posed nude in a fan publicity photograph on the left: Both are posing with their faces turned sideways, with the effect of their eyes coyly glancing up towards the viewer. While his attraction to her is clear, we can sense that she was just having an intimate moment with him, accompanied by drinks and evidence of an evening out together. Her note, written onto the page in German, gives him a kiss...

In the next page, Gert-Christian's focalized gaze on the many faces of Angie Stardust is even more intense for not being present in the photographs. Angie's pout, her dark-lined eyes, and strong cheekbones are alluring, even more so because they are duplicated in one pink-toned and one black-and-white version. As an African American from Harlem, New York, Angie Stardust performed as a drag star until her taking of hormones challenged the reigning "rules" of drag, and she departed for Germany where she found fame in singing and acting as well as business success in running nightclubs. On this page, Gert Christian's declaration addressed to Angie—I love you—sums up the sentiment of t4t. Through thick and thin, in all the various idioms and greater meanings, love is what it is about.

The History of Love

I began with the perspective offered by Stryker of trans history being about trans people looking at records with their sensibility and clocking the transiness of a fellow time traveler. For her, the positionality of the look and how it acknowledges its own framing desire is crucial. Here, I conclude my offering of a translover-focused visual language for all things t4t, aware that I am wading into the difficult waters of questions regarding the proper conduct of historical investigations. I have turned to historical materials, citing affective continuity in an effort to draw on the building blocks we may need today to feel less alone. In his discussion of trans-centric artistic projects, Jack Halberstam raises the question of methodology in tracking the disorderly histories of trans*, and he shifts the focus to the capacious

notion of transiness and its various kinship networks.[24] His inspiration is the "merographic" method developed by feminist science scholar Sarah Franklin—first originated by anthropologist Marilyn Strathern—that expands the possibility for family relations beyond direct descendants. Following them, Halberstam transposes this notion of kinship onto seeing trans bodies in networks related to each other. Acknowledging our "merographic connections" to each other means recognizing that as a group, we are never part of one whole, but can belong to multiple groups or wholes simultaneously. We need to see trans* bodies differently in relation to each other, he explains, not just "provide an image of the non-normative against which normative bodies can be discerned."[25] And this calls for a side-by-side-ness of trans-relationality that I believe can be found in t4t configurations. t4t refuses the violent gestures of taking one person as a part that represents a whole community. It relocates the generation of meaning inside a circulation of one for another, of this kind for this kind. The word kin, of course, is related to kind. In returning to the mini scrapbook of t4t visual iterations that I've created here, I'm reminded that someone saved these pictures, then someone else saved them, now I save them again in a new form. What does this tell us about generational transfer of care and preservation? I've not only responded in kind but want to pass on this responsibility, to claim the right to look to you. Carry the torch as it were, and find your own flame too.

24 Jack Halberstam, "Trans* – Gender Transitivity and New Configurations of Body, History, Memory and Kinship," *Parallax*, vol. 22, no. 3 (2016), pp. 366–75, 370–71.
25 Ibid., p. 371.

Corporeal Literacy

In a scene not long after the beginning of *The Matrix*, we witness the protagonist Neo during his first combat training session. Laying back in what looks like an old-fashioned dentist chair, he is connected to a computer system by means of a plug in the back of his head. On a small computer screen in front of him, we see a schematic image of a body in kung fu poses, reminiscent of a "How to do Kung Fu" manual. Instead of learning kung fu from these images, he lays back with his eyes closed while things seem to be happening inside his body. For, although Neo is laying back in his chair, we are also given all kinds of signs that his body is very actively involved in something. Ten hours later, he opens his eyes and says: "I know kung fu."[1]

What does he know? How does he know it? What does it mean to *know* kung fu? To know kung fu, in this film, is to be able to move, respond, anticipate, and improvise in a kung fu-ean manner. Neo is challenged to demonstrate his knowledge of kung fu in a friendly contest with his master Morpheus. The actual goal of him learning kung fu, however, goes beyond his ability to meet his master's challenge. Kung fu is presented as a tool to make him think differently. Not by explaining or showing him that things are different than previously thought, but by changing his way of responding to what he encounters. Through kung fu, Neo learns to move anew, and this is shown to transform his modes of enacting perception as well. Through these new ways of moving, Neo learns to engage with what he encounters in new ways, and even to think in new ways—he develops a new literacy.

Although literacy is traditionally associated with language and books, the use of the term is no longer limited to this context. Over the past decades, various other literacies have been proposed, expanding the notion of literacy beyond the domain of the written and printed word. Literacy is used to describe the skills involved in interpreting various information, as in visual literacy, media literacy, or aural literacy. Likewise, corporeal literacy aims to expand the notion of literacy but in a slightly different way. Unlike the "media" in media literacy, "corporeal" in corporeal literacy does not denote a class of information or an aspect of objects being read but rather refers to the

1 Lana and Lilli Wachowski, *The Matrix*. Hollywood, CA: Warner Bros. et al., 1999.

corporeal dimensions of perception and sense making and to how these corporeal dimensions are informed by practices of doing, by the affordances of tools and technologies, by the environments with which humans engage, as well as by habits and practices they have incorporated. This emphasis on the corporeal dimensions of perception distinguishes corporeal literacy from *corpoliteracy*—proposed by Bonaventure Soh Bejeng Ndikung in Volume 3 of this series, *Counter_Readings of the Body*—although the term likewise acknowledges the body as a site and "a medium of learning, a structure or organ that acquires, stores, and disseminates knowledge."[2] Going further, corporeal literacy as a conceptual tool sheds light on how the sedimented effects of bodily practices co-shape the human mind and the ways in which we perceive and make sense. Mind here does not refer to something existing separately from the body. Rather, what we conceive of as "mind" emerges from the interaction of our bodies with the world we encounter—including as part of our coevolution with technology—that is, the bodymind.

Literacy, Technology, and the Mind

This understanding of corporeal literacy builds on and moves beyond Walter Ong's conceptualization of literacy as the cultural condition or "mind-set" that has resulted from the widespread use of the technologies of writing and print.[3] More than providing human users with a means to capture, store, and transmit spoken language, these technologies, Ong argues, quite literally changed people's mind-sets. Ong locates these transformations in the way writing and print turn language from an aural-transitory phenomenon into a visual-spatial one, which affords new ways of handling language and relating to it. Importantly, Ong's account of the impact of the invention of writing and print technology is not concerned solely with what the use of language does per se. It is not about what words do to the mind, but

2 Bonaventure Soh Bejeng Ndikung, "CORPOLITERACY," in Daniel Neugebauer (ed.), *The New Alphabet, Volume 3: Counter_Readings of the Body*. Leipzig: Specter Books, 2021, p. 22. First published in: Sepake Angiama, Clare Butcher, Alkisti Efthymiou, Anton Kats, Arnisa Zequo (eds), *aneducation - documenta 14*. Berlin: Archive Books, 2019, pp. 114–21.
3 Walter J. Ong, *Orality and Literacy: The Technologizing of the Word*. London: Routledge, 1988.

about the transformations in modes of managing knowledge, of thinking, and of being which are brought about by extensive interaction with the medium of writing and print.

Once written down, words gain an existence independent from the situation of utterance, can circulate independently, accumulate in libraries, be categorized, cut into smaller pieces, analyzed in new ways, and accessed time and again at different places and times. Writing and print thus support "a sense of closure, a sense that what is found in a text has been finalized, has reached a state of completion," creating the new modes of imagining and thinking that Ong proposes as "the mind-set of literacy."[4] Such closure pertains not only to the writing itself but also to the possibility that knowledge can be definitive, exhaustive, and all-encompassing, as well as an understanding of knowledge as something that can be placed somewhere and ordered. Writing and print partake in a "spatialization" of knowledge that is also manifested in taxonomies, indexes, charts, and maps: all modes of knowing that seek to determine the position of individual elements in a totality. Such knowledge places the knowing entity in a position of overview, at a distance from and outside a spatially ordered objective system.

Many have reflected on this supposed objectivity, drawing connections between the silent and individual practice of reading and the emergence of the modern Western subject, characterized by a sense of disconnection between the private interior mind (doing the reading and the thinking) and the public exterior body. That is, reading written or printed language facilitates particular modes of attentiveness and supports a sense of self or "I" as first and foremost located in the mind. Such a disembodied "I" can never truly be attained however, because, as Brian Rotman—in his *Becoming Beside Ourselves: The Alphabet, Ghosts, and Distributed Human Being*—shows:

> "[B]efore disembodied agencies come embodied ones. Alphabetic writing, like all technological systems and apparatuses, operates according to what might be called a corporeal axiomatic: it engages directly and inescapably with the bodies of its users. It makes demands and has corporeal effects."[5]

4 Ibid., p. 129.
5 Brian Rotman, *Becoming Beside Ourselves: The Alphabet, Ghosts, and Distributed Human Being*. Durham, NC: Duke University Press, 2008, p. 15.

Although Ong observes the shift from the aurality of speech towards the visuality of language to be key to the emergence of the "mind-set" that is literacy, he does not reflect on the embodied implications of this shift more than observing that, as an aural phenomenon, language has no permanent existence—since, as he explains, sound disappears while being uttered—while as visual phenomenon it has longevity. That is, Ong points to how writing changes the way in which language is present for perception, yet he does not reflect on what writing does to perception and to bodies engaged in perceiving.

Writing proceeds by means of a symbolic notation of the sounds of speech through visual signs. This symbolic notation requires from the reader the capacity to read the letters in terms of the sounds they stand for, as a result of which successions of letters become recognizable as words. Understanding how to read written language requires learning to read what is seen in terms of these sounds. The difference between speech and writing, therefore, is not (or not only) that writing turns spoken language into a visual phenomenon, but also that speech (either live or recorded) requires us to make sense of what we hear, whereas written language requires us to make sense of what we see in terms of sound. Writing thus alerts us to perception as a bodily grasping that involves our senses, or, as James Gibson puts it, as perceptual systems through which we make sense of what we encounter.[6] This therefore changed the embodied hierarchy of the senses when it came to perception.

Writing and print also operate on the bodies of their users through the practices they afford, the routines, patterns of movement, and gestures involved in using them, and through the perceptual activities that are mobilized by the medium or that are part of the background conditions that brought the medium about. Technologies like writing and print impose what Rotman describes as their "mediological needs" on the bodyminds of their users. They facilitate behavior and engage their users in patterns of action and/in perception, the effects of which extend beyond any technologies' explicit functioning and beyond the evident perceptual and cognitive skills required to use them.[7] The logic of these effects, Rotman observes, is

6 James J. Gibson, *The Ecological Approach to Visual Perception*. Boston, MA: Houghton Mifflin, 1979.
7 Ibid., p. 82.

not one of representation but of enactment: of how media engage bodies of users in patterns of action and perception, of how they propagate some behaviors and suppress others.

The fact that most humans are capable of engaging with language as a visual-spatial phenomenon is a matter of capacities given in the structure of human embodiment to see writing and produce it. In this sense, the invention of the technology of writing and print meets with the pre-existing potential of bodies. The same might be argued about more recent technologies. The control mechanisms of a smartphone, for example, are designed to meet the potential of bodies to perform certain movements. Humans able to perform these movements are therefore capable of using these technologies. However, in using these movements to interact with the touch screens of devices, the movement skills to engage with these technologies become part of something they were not before. They become part of navigating through information, finding the right piece of music, scrolling through lists of data, communicating with friends and strangers, and organizing and making connections between diverse materials. As a result, the skills involved in performing these movements become part of how bodies make connections, how they relate to what they encounter, and how they make sense of it. These new technologies now mediate in the handling of information and, by extension, hold the potential to change modes of understanding and thinking, including our understanding of what knowledge is and what it means to know.

Literacy thus understood describes a situated condition that results from how, once incorporated, those skills acquired from the use of writing and print affect modes of understanding, not only of language but also of other things: of the world, of human "selves." Similarly, corporeal literacy is not about how language affects bodies or how bodies are involved in how we make sense of language. It is about what the medium of writing and print, as well as other technologies, do to bodies and vice versa. How do technologies afford modes of engaging with knowledge that respond to the bodies' potential for perception and understanding? At the same time, how do technologies mediate the development of new cognitive perceptual skills and, by extension, new modes of thinking and imagining?

The Mind, the Body, and the World

Insights in corporeal literacy also find parallels in current developments in enactive cognition. From an enactive-cognition perspective, perception and understanding are grounded in bodily practices that contribute to the building of sensorimotor schemata or skills in interaction with the environment. These skills or schemata provide an answer to what Alain Berthoz describes as the fundamental problem of perception—unity.[8] Human bodies have a great number of sensors through which they are capable of receiving stimuli. Sensory inputs are therefore multiple, manifold, ambiguous, staggered over time, they do not cover the same range of velocities, and they are often fuzzy and incomplete. And so, as Berthoz writes, "Perception is an interpretation; its coherence is a construction whose rules depend on endogenous factors and on the actions that we plan."[9] According to enactive approaches, sensorimotor schemata (Berthoz) or sensorimotor skills (Noë) are crucial to creating this unity, acting as blueprints for possible action and organizing perception even before sensory stimuli are processed. These schemata, Berthoz points out, are not sets of data but organizing frameworks for understanding relationships between action, perception, and memory. They are part of how bodies engage with what they encounter, and they presuppose certain capacities given in the structure of our embodiment. For example, the possibility for humans to develop the ability to walk up and down stairs requires particular physical possibilities. Once they have learned to do so, this embodied knowledge will be incorporated into a wider schema that includes memory, particular physical strengths, the interpretation of visual stimuli, an implicit understanding of the workings of gravity, and so on.

Referring to these capacities as sensorimotor skills (rather than sensorimotor schemata), Alva Noë highlights the fact that these capacities are not merely given but have to be acquired in and through experience.[10] Neo's kung fu training illustrates his observation that "*What we perceive* is determined by *what we do* (or what we know how

8 Alain Berthoz, *The Brain's Sense of Movement*. Cambridge, MA: Harvard University Press, 2000, p. 90.
9 Ibid., p. 91.
10 Alva Noë, *Action in Perception*. Cambridge, MA: MIT Press, 2004.

to do); it is determined by what we are *ready* to do."[11] Perception, Noë points out, is not an activity in the brain but a skillful activity on the part of the animal as a whole. And the basis of perception is implicit practical knowledge of the ways movement gives rise to changes in sensory stimulation. For example, reading requires the implicit knowledge that movement of the eyes to the right produces leftward movement across the visual field. Eating requires the implicit knowledge that, when looking at one side of, say, a tomato, what is in front of us is a whole tomato; what we see is the presence of a three-dimensional object in space. Even in the dark, or with our eyes closed, we can touch different sides of a box and not only feel a succession of surfaces but grasp their spatial relationships as different sides of the same box. Such a perceptual sense of presence results from our practical grasp of sensorimotor patterns that mediate our presence in relation to what we are perceiving. Perceiving is not merely to have sensory impressions but rather to *make sense of* sensory impressions, and this happens through our sensorimotor skills. This understanding is not only constitutive of our experience of the world, but also is the root of our ability to think about it.

This makes Noë's theory of enactive cognition particularly interesting for a non-representational understanding of literacy as a corporeal condition. His approach suggests that bodily practices and ways of interacting with technologies and the environment may affect the ways in which sensorimotor skills come about and thus co-shape the ways in which human beings perceive and order information. Enactive cognition approaches like Noë's therefore also call into question the assumption that perception and cognition "consist of the representation of a world that is independent of our perceptual and cognitive capacities by a cognitive system that exists independent of the world" and instead propose a view of perception and cognition as embodied action.[12]

This concept is explored imaginatively in *The Matrix*, where humans receive electrical stimuli via the plug in the top of their spinal column, which are interpreted by their bodies and from which the world of the matrix emerges as a world with a visible, audible,

11 Ibid., p.1 (italics in the original).
12 Francisco J. Varela et al., *The Embodied Mind: Cognitive Science and Human Experience.* Cambridge, MA: MIT Press, 1992, p. xx.

tangible existence, a world in which they can participate through what they perceive as fully embodied interaction. In *The Matrix*, this world is opposed to a world that is material and that—like Plato's "real world" outside the famous allegorical cave—exists elsewhere, known only by some enlightened beings and in constant threat of being destroyed by the same machines that produce the illusionary world that most humans are caught within.[13] The narrative of the movie thus reiterates a well-known binary opposition between the digital and the material: that technology provides mere illusions, which prevent us from direct engagement with the more real, material world. Interestingly, however, the last human venue in *The Matrix* is not projected outside but inside a cave, somewhere deep down below the surface of the Earth. Outside is the "desert of the real," a post-apocalyptic world destroyed by machines that have outsmarted human beings and now keep humans locked in the technological surroundings that produce the illusionary world. On either side, humans find themselves locked within.

A central theme in both Plato's allegory and *The Matrix* are the limitations to knowledge and how these limitations keep humans imprisoned. Whereas Plato's allegory suggests that the way to liberation is to be found in leaving the body behind, in *The Matrix*, it is through his body, and in particular through movement, that Neo learns to understand his world anew, including the world that is produced by the technology referred to as the matrix. The way to liberation is imagined here as an embodied understanding of the rules that govern his world and also how "some of these rules can be bent, others can be broken" (as stated by the character Morpheus). In *The Matrix*, enlightenment does not happen to the Cartesian "I think" to whom the world is a spectacle, but to Merleau-Ponty's "I can" to whom the world is given as a system of possibilities and as potential for

13 The allegory of the cave is introduced in the seventh book of Plato's *The Republic*. The allegory describes a group of people who have lived their entire life in a cave. Chained to one wall, they watch shadows projected on a blank wall in front of them, generated by objects passing in front of the light from a fire which is behind them concealed by a low wall. They take these shadows for reality. The allegory compares philosophers to prisoners who, once freed from the cave, come to understand that the shadows on the wall are actually not reality at all.

action.[14] Furthermore, *The Matrix* suggests that, approached in this way, technology does not limit but actually expands our potential for action, and through this, also our potential for imagining and thinking.

Crucial to Neo and his fellow freedom fighters is their development beyond being either locked within the technically produced world or within their real-world cave, instead learning to move between the two. In doing so, we might say that they learn to engage with their world in terms of what Mark Hansen (after Monika Fleischmann and Wolfgang Strauss) refers to as "mixed reality."[15] Mixed reality describes a situation in which the virtual is no longer conceived of as a separate realm, distinct from the real, but a dimension of reality opened up by technology. Or, as Hansen puts it:

> "Rather than conceiving the virtual as a total technical simulacrum and as the opening of a fully immersive, self-contained fantasy world, the mixed reality paradigm treats it as simply one more realm among others that can be accessed through embodied perception or enaction."[16]

In the mixed reality paradigm, virtuality emerges from the various ways in which our interaction with technology expands our reality and affects human behavior. This leads Hansen to his observation that mixed reality turns an ontological condition—in this case, that our reality has been expanded by technology since the very first use of tools—into an empirical reality. Mixed reality, he observes, "appears from the moment that tools first delocalized and distributed human sensation, notably touch and vision."[17] Today's virtual reality technologies expose this technical conditioning of experience and foreground

14 The Cartesian "I think" refers to René Descartes' famous saying "I think therefore I am." With this, Descartes identifies being with thinking, and the mind as the site of self or "I." In his *Phenomenology of Perception* (London: Routledge & K. Paul, 1962), Maurice Merleau-Ponty argues against this Cartesian understanding. Replacing "I think" with "I can," he draws attention to the ways in which being and thinking are grounded in the body and its capacity for action.

15 Mark B. N. Hansen, *Bodies in Code: Interfaces with Digital Media*. London: Routledge, 2006, p. 2.

16 Ibid., p. 5.

17 Ibid., p. 9.

what Hansen describes as "the constitutive or ontological role of the
body in giving birth to the world."[18] This bodily basis of experience
"has *always* been conditioned by a technical dimension and has *always*
occurred as a cofunctioning of embodiment with technics."[19]

Hansen's observations point to how human modes of perceiving,
experiencing, acting, and thinking are thoroughly intertwined with
the technologies we use. Technologies—like our computers or the
above-mentioned smartphones—are not merely technical extensions,
we actually perceive and think through them. This is what leads Andy
Clark to his assertion that human beings are natural-born cyborgs.[20]
Bernard Stiegler, Katherine Hayles, and Hansen refer to this as *tech-
nogenesis*: the human coevolution with technology.[21] The proposition
recurring in their works is that humans—and what we associate with
the human mind and thinking—coevolved with the tools humans
developed and deployed. This is supported by research in radically dif-
ferent fields, namely palaeoanthropology and evolutionary neurology.

Long before it was possible to imagine the kind of intimate
intertwining of humans and technology envisaged in *The Matrix*,
humans have been "natural born cyborgs" in the sense that their
modes of encountering the world took place in interaction with tech-
nologies of various kinds. Terrence Deacon observes that:

> "Stone and symbolic tools, which were initially acquired with
> the aid of flexible ape-learning abilities, ultimately turned

18 Ibid., p. 5.
19 Ibid., pp. 8–9.
20 Andy Clark, *Natural-Born Cyborgs: Minds, Technology, and the Future of
 Human Intelligence*. Oxford: Oxford University Press, 2004.
21 Bernard Stiegler, *Technics and Time 1: The Fault of Epimetheus*, trans.
 Richard Beardsworth and George Collins. Stanford, CA: Stanford
 University Press, 1998; Bernard Stiegler, *Technics and Time 2:
 Disorientation*, trans. Stephen Barker. Stanford, CA: Stanford University
 Press, 2009; Bernard Stiegler, *Technics and Time 3: Cinematic Time
 and the Question of Malaise*, trans. Stephen Barker. Stanford, CA: Stanford
 University Press, 2011; Katherine N. Hayles, *How We Think: Digital
 Media and Contemporary Technogenesis*. Chicago, IL: Chicago University
 Press, 2012; Mark B. N. Hansen, *Embodying Technesis: Technology
 Beyond Writing*. Ann Arbor, MI: University of Michigan Press, 2003;
 Hansen, *Bodies in Code*.

the tables on their users and forced them to adapt to a new niche
opened by these technologies. Rather than being just useful
tricks, these behavioural prosthesis for obtaining food and
organizing social behaviours became indispensable elements
in a new adaptive complex. The origin of "humanness"
can be defined as that point in our evolution where these tools
became the principal source of selection on our bodies and
brains."[22]

To paraphrase Noë, interactions with technology changed *what we do*,
what we *know how to do*, and what we *are ready to do*, and in doing so
also transformed modes of perceiving and thinking. Referring to
Clark, Rotman observes that the human:

"[...] has from the beginning of the species been a three-way
hybrid, a bio-cultural-technological amalgam: the 'human
mind'— its subjectivities, affects, agency, and forms of con-
sciousness— having been put into form by a succession of
physical and cognitive technologies at its disposal."[23]

Whereas Ong's argument is constructed around an opposition of oral-
ity and literacy, in which orality problematically seems to stand for a
more natural, pristine, and primitive condition and literacy for culture
and progression, Rotman points out that what writing and print do to
human bodyminds actually builds on and extends previous cognitive
perceptual practices resulting from the invention of speech. Further-
more, as he and many others have pointed out, writing is not the only
medium that imposes "mediological needs" on bodies—so too do
other technologies, environments, and bodily practices. From this
perspective, what Ong describes as the mind-set of literacy represents
only one particular aspect of a much longer, complicated, and diverse
history in which writing and print are part of a broad array of physical
and cognitive technologies that have shaped, and are shaping, human
bodyminds. For just two examples amongst many works in which this

22 Terrence Deacon, *The Symbolic Species: The Co-evolution of Language
 and the Brain*. New York: Norton, 1997, p. 345, quoted from Rotman,
 Becoming Beside Ourselves, pp. xix–xx.
23 Rotman, *Becoming Beside Ourselves*, p. 1.

more complex picture has been explored, Friedrich Kittler has shown how the gramophone, film, and the typewriter have become part of how we think;[24] Gilles Deleuze famously argued that cinema has transformed modes of thinking and imagining in modernity, and explains this through how montage and the film camera place new kinds of demands on our sensorimotor schemata.[25]

Going further in terms of situating these theories in particular times and places, in his *Techniques of the Observer*, cultural theorist Jonathan Crary shows how technologies like the camera obscura and the stereoscope can be considered paradigmatic for culturally specific modes of perceiving and thinking and for culturally specific conceptions of perception and embodiment.[26] In his subsequent book, *Suspensions of Perception: Attention, Spectacle, and Modern Culture*, Crary demonstrates that such modes of perceiving are not merely the result of actual encounters and interactions with specific technologies, but that these interactions with technologies get incorporated and thus transform ways of perceiving and understanding.[27] Like Ong's, the work of these theorists points to how technologies affect ways of perceiving, imagining, and thinking, and they show that the ways in which they do so are not only a matter of our actual interaction with them but extend well beyond that to become part of naturalized—yet culturally and historically situated—modes of understanding.

Conclusions

The Matrix is, of course, fiction. In fact, *The Matrix* is interesting precisely as science fiction, that is, as an extrapolation from the 1999 state-of-the art in science and technology: an informed fantasy of where we might go in the future. Although it seems unlikely that the

24 Friedrich Kittler, *Gramophone, Film, Typewriter*, trans. Geoffrey Winthrop-Young and Michael Wutz. Stanford, CA: Stanford University Press, 1999.
25 Gilles Deleuze, *Cinema I: The Movement-Image*, trans. Hugh Tomlinson and Barbara Habberjam. Minneapolis, MN: Minnesota University Press, 1986.
26 Jonathan Crary, *Techniques of the Observer: On Vision and Modernity in the Nineteenth Century*. Cambridge, MA: MIT Press, 1990.
27 Jonathan Crary, *Suspensions of Perception: Attention, Spectacle, and Modern Culture*. Cambridge, MA: MIT Press, 1999.

next generation of "How to" manuals will be delivered via a brain plug, first steps have already been taken in the development of brain-computer interfaces. Research into neural plasticity has demonstrated that it is possible to reorganize brain functions and make the brain interpret electrical impulses detected through the tongue as visual images, or impulses from an implant in the inner ear as sound. Such research points to the possibility of humans participating in an environment in which visibility and audibility do not necessarily precede perception but emerge from their embodied response to these impulses. This would result in further changes to the capabilities, hierarchies, and technologies that constitute and change the way humans perceive the world, much like the changes brought about by Neo's kung fu training.

At the time of his writing in the early 1980s, Ong observed that telephone, radio, television, and various kinds of sound recording began to alter the mind-set brought about by writing and print. He suggests that these technologies have the potential to bring about a "secondary orality." His choice to describe this new phase as a "secondary *orality*" (rather than further developments of literacy) seems to be inspired by the then-rising prominence of media that capture and transmit spoken rather than written language. The suggestion that this would mean a return to orality, however, is a denial of the difference between speech and speech-that-is-mediated. It is a denial therefore precisely of mediation: of how sound recording, radio, and television are also means of what the subtitle of his book describes as "technologizing the word," albeit in different ways. Both writing and recording evoke a disconnection of the utterance from a speaker and the situation of speaking, and require from a listener the capacity to relate to language thus disconnected. Both give language a semi-permanent existence, as something that can be stored, ordered, catalogued, and accessed time and again and in different places and times. Both afford language the ability to be dissected into smaller pieces, to be analyzed and recombined. That is, both provide many of the developments that Ong considers as constitutive of the mind-set that is literacy.

This demonstrates that bodies can reorganize how the various sense modalities are encountered as visible and audible, and both at the same time. Such reorganizations are indicative of transformations in how bodies are corporeally literate. But, just as the technology

of writing and print did not mean the end of speech, so the emergence of other technologies does not mean that writing will be replaced by them, nor that the effect of older technologies on ways of perceiving and thinking is simply undone. Rather, the ways in which bodies are corporeally literate bears the traces of histories of engagement with various technologies and environments as well as with other bodily practices like training and habits. How bodies are corporeally literate is in constant transformation and involves both the sediments of widespread uses of technologies and other practices of doing and imagining; they are part of how individuals are culturally and historically situated and the effects of their individual trajectories and choices. Corporeal literacy as a conceptual tool thus directs attention to these sediments and how they inform ways of perceiving and making sense, and how what we experience as our perceptions, our ways of understanding, are jointly shaped by histories of intra-actions of human bodies and the demands placed on them by the worlds they encounter.

"How could you tell me
that you don't have an idea about
how you want your
hair for the wedding day?"

Bridal hairdresser

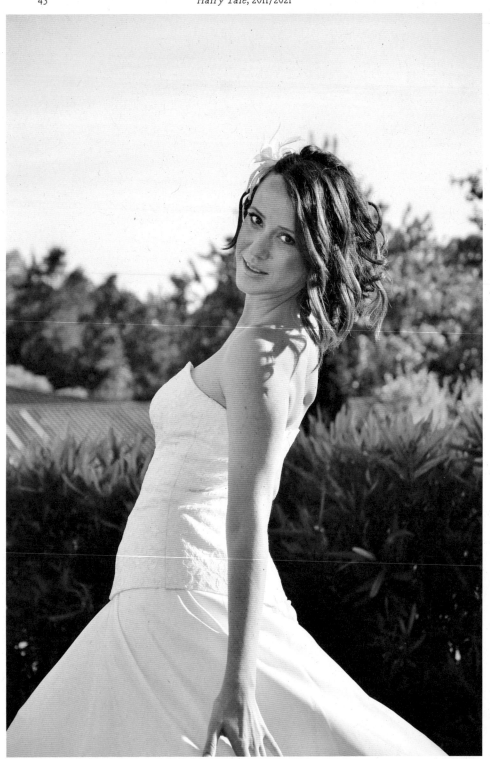

"It is hard to be a bride.
Well, it is hard
to be a woman in general."

Bridal hairdresser

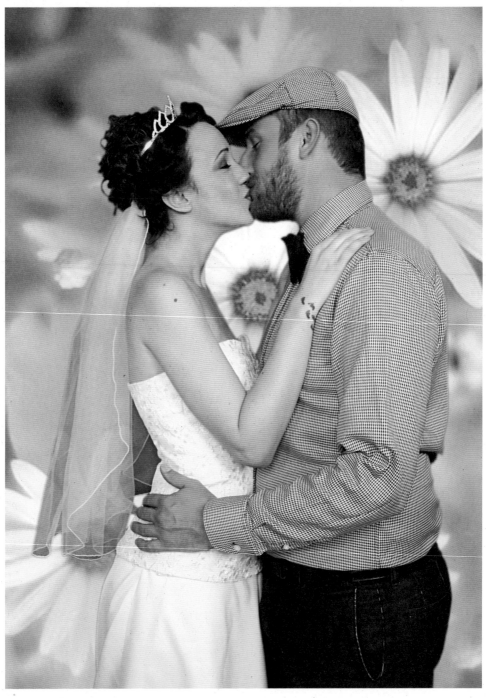

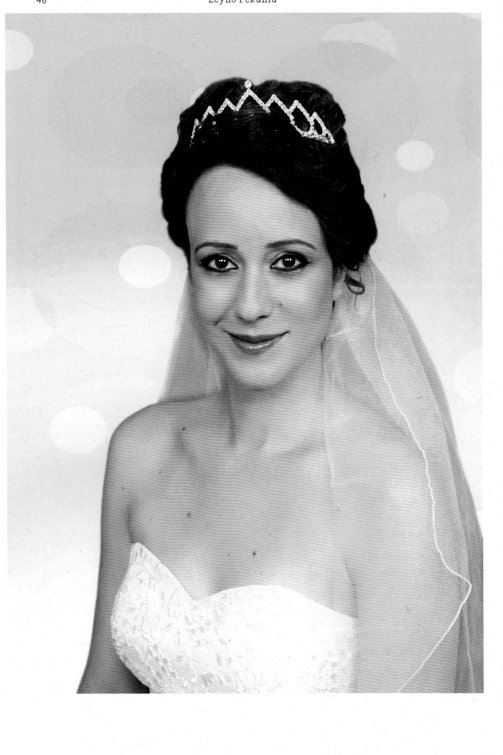

"I never ever want to get married."

Bridal hairdresser

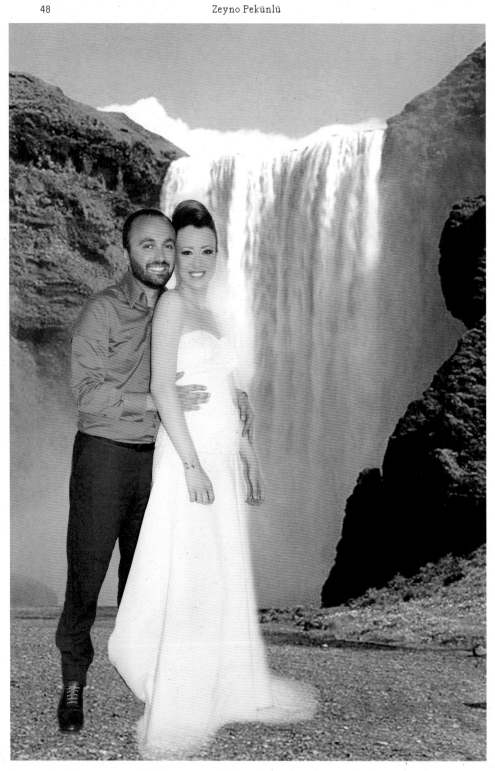

interrupt

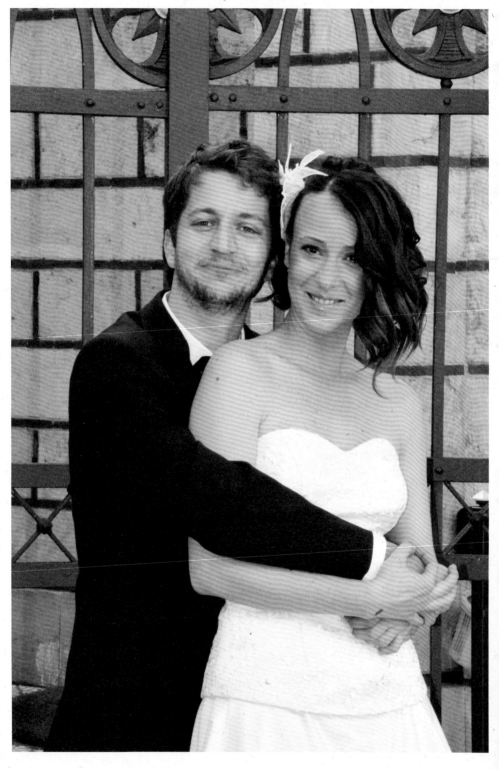

Hairy Tale, 2011/2021

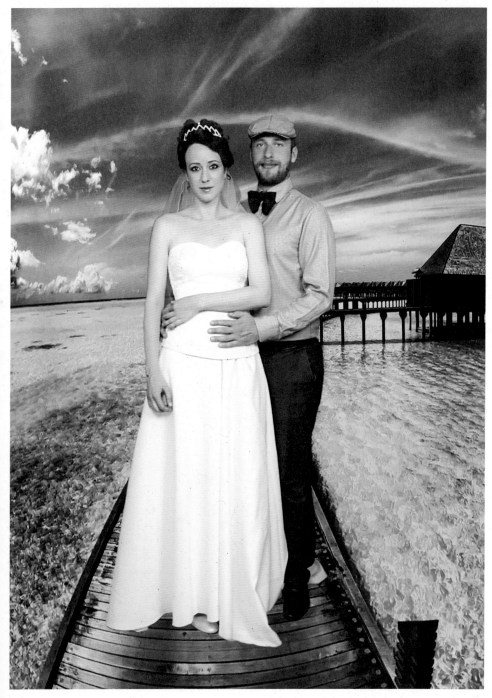

"Hold the bride gently
as you hold a delicate flower
and tell her to smile."

Wedding photographer

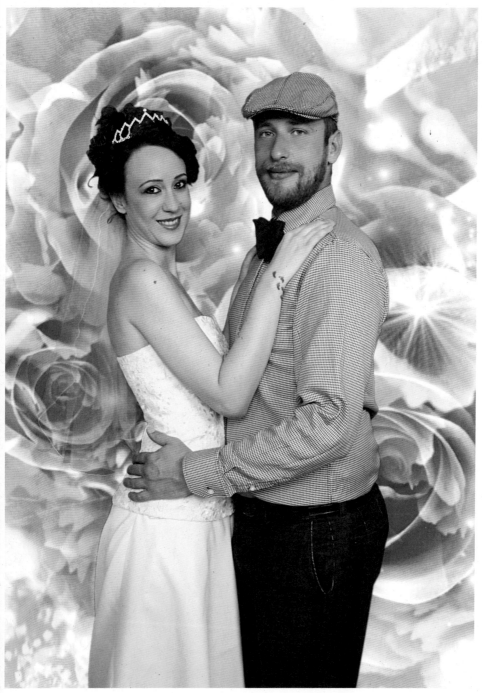

"It is normal not being able to sleep
the night before the wedding.
You were probably thinking if it is
the right decision."

Make-up artist

"I am sure you did it
a million times,
don't be shy and just tell me
what style of a hair
you want!"

Bridal hairdresser

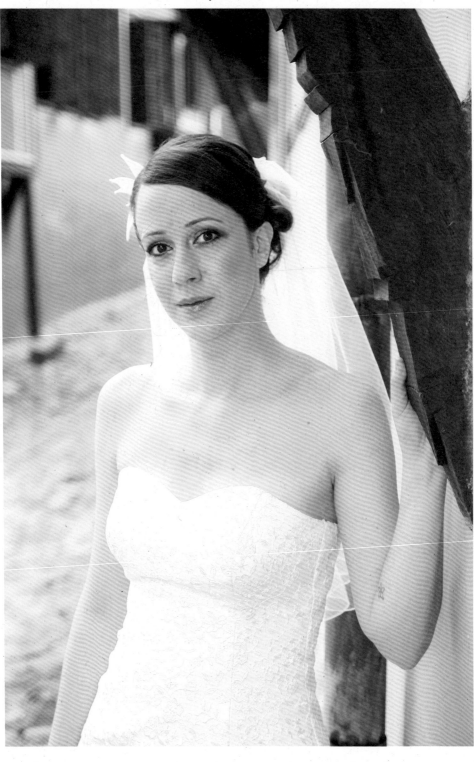

Revision of a Text on
Othered Bodies in Art Education:
A Discrimination-Critical
Reflection Loop

In the early 2000s, I accompanied artists in England whose work was engaged in a power-critical form of gallery education. My intention was to systematize conceptual frameworks and methods for a critical practice at the interface of education and art.[1]

Among other things, I wrote a text about a concrete situation I had witnessed in a London public gallery, surrounded by Ludwig Mies van der Rohe models.[2] The artist-educator leading the visit was the only *white* person (apart from the female teacher and me in the role of observer)—her light, functional clothing and manner seemed in keeping with the institutional setting and were unmarked. The other participants, a group of twelve- to thirteen-year-old schoolgirls from a local school, were PoC, wearing hijabs and dark school uniforms. Their presence interrupted what Nirmal Puwar, in her book *Space Invaders*, calls the "somatic norm" of a context.[3]

The artist-educator gave the young women a worksheet she had created with action-oriented suggestions for critical observation—not only of the architectural models, but also of the exhibition space in which they found themselves. After a short while, the young women had forgotten about the worksheet. They started playing with the yellow stickers they had received at the entrance and which they had to wear on their clothing to indicate that they were legitimized visitors to the exhibition. They removed these stickers from their school uniforms and stuck them in the hair of a classmate who was filming

1 I use the phrase "interface of education and art" as an umbrella term. It refers to all areas of educational work in, with, and through the arts: art, music, and theater classes in schools, cultural education inside and outside institutions, arts education, outreach work in cultural institutions.

2 Carmen Mörsch, "Application: Proposal for a Youth Project Dealing with Forms of Youth Visibility in Galleries," in Anna Harding (ed.), *magic moments: collaboration between artists and young people*, London: Black Dog Press, 2005, pp. 198–205.

3 Nirmal Puwar, *Space Invaders: Race, Gender and Bodies Out of Place*. Oxford: Berg, 2004.

the architectural models with a video camera (the only one pursuing a task proposed by the artist-educator). The many yellow dots in her hair looked beautiful and festive. The students laughed a lot during the activity and hardly followed the institutional script. They disturbed the contemplative, museum-like atmosphere of the White Cube. Yet no one called them to order. On the contrary, the attendants, also mostly PoC, joined in the laughter and let the pupils do their thing.

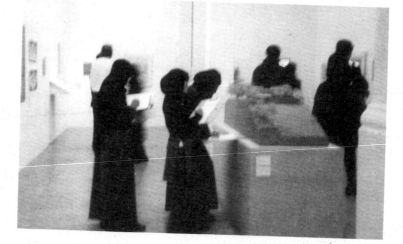

The 2005 text I wrote about this situation is focused on a critical analysis of representation. It is primarily about the visibility of othered bodies in gallery education and their instrumentalization in the context of diversity imperatives. I make suggestions for approaches to power-critical ways of documenting gallery education. I am concerned, above all, with the demand that all those involved in a teaching situation should participate in the work of representation. The text draws attention to the students' subversive appropriation of the exhibition, highlighting its potential for different modes of representation.

In the following, I return to my previous reflections, re-examining them through a discrimination-critical lens by means of which I currently interrogate work at the interface of education and art. For some time now, I have been involved in the education and training of actors within this interface, drawing on the concept of "critical diversity literacy" by *white* South African communication scholar Melissa Steyn.[4] The goals of the educational work I want to set in motion in relation to this concept are sensitization, qualification, and structural change: those professionally involved in the art/education interface, as well as their institutions, should sensitize themselves to a discrimination-critical perspective, and qualify for a resulting practice. Underrepresented social groups should be supported in working and researching in these fields. Steyn and her team have formulated indicators that comprise a discrimination-critical literacy:

4 Melissa Steyn, "Critical Diversity Literacy: Essentials for the twenty-first
 century," in Steven Vertovec (ed.), *Routledge International Handbook
 of Diversity Studies*. London: Routledge, 2007, pp. 379–89. Steyn explicitly
 draws on the concept of racial literacy by Black British sociologist and
 filmmaker Frances Winddance Twine.

—Understanding that categories of difference such as gender, sexual orientation, disability, class, and racialization are learned and socially produced.
—Understanding what intersectionality is, i.e., the ability to recognize the interplay of these categories in the production of inequality.
—Understanding what being privileged means against this backdrop.
—The ability to undertake a critical self-positioning on this basis.
—Developing a willingness to change towards more justice.
—Possessing a language and terms to name inequality and relations of domination.
—The ability to recognize/decode hegemonic forms of address.
—Understanding the continuities of historically developed power relations in the present.[5]

Applying these criteria to my remarks from 2005, I can see, on the one hand, what my analysis achieved back then. My critical approach to representation shows that as a writer I had the ability to recognize and decode hegemonic forms of address. This was based on my awareness that categories of difference are fundamentally learned and socially produced. The proposals I develop with regard to possible critical practices of representation in gallery education reflect my willingness to change towards more justice. I owe this special kind of being educated, which is articulated in the text and has significantly shaped my work to this day, to the readings and discussions during my degree in cultural and gender studies at the Carl von Ossietzky University Oldenburg (completed between 2001 and 2003), and which introduced me to the writings of Roland Barthes, Judith Butler, Michel Foucault, and Stuart Hall, among others.

The discrimination-critical revision of my 2005 text, on the other hand, also clearly reveals the gaps in this state of being educated. They essentially concern intersectional analysis, the recognition of the effects of privilege, such as *white*ness and, to some extent, class, and—related to this—of historical continuities in concrete educational

5 I adapted the order of the indicators for didactic reasons, but it is to some extent contingent and in any case exemplary, since educational processes are not linear and the indicators must be seen as intertwined.

situations. I had noted that the artist-educator leading the visit was aware of the fact "that, besides the teacher, she will be the only *white* person in the group and that this also perpetuates, at least visually, the Victorian and philanthropic tradition in which the phenomenon of education through art in the gallery is historically founded. And she is just as aware of the function of the galleries and museums as a 'civilizing ritual.'"[6] But that is all. I barely call into question my own presence and its influence on the observed situation. Above all, I fail to elaborate on the level of structural violence that confronted the students in this institutional setting. The continuity of historical power relations does not merely apply to the Victorian philanthropic tradition of art institutions since the nineteenth century. The fact that primarily *white*, middle-class cis women still work at the interface of education and the arts is connected to their own historical struggles for public spaces of articulation and the recognition of being "different but equal" to their male counterparts. This political struggle relied on the discursive production of a deficient alterity, at the expense of the devalued subjects (in terms of both race and class), whom the care and educational work of these women were aimed at.[7] Here, then, is the essential insight that enables me to reread the educational situation in my text in a way that is informed by Critical Diversity Literacy: the critique of power, to which both I as a researcher and the artist-educator were committed, did not prevent us from recreating, as it were, a living image of historically grown power relations in the exhibition space. The powerful omissions of our feminist critical education were due to the latter's *white* and, to some extent, classist perspective and its resulting ignorance. The reading lists for my degree in cultural and gender studies, for instance, contained no works of Black feminism, which were already decrying these epistemological gaps in the 1980s.[8] The *white* spots in my reading ability at that time are also reflected in some of the vocabulary used in the text: for example, I write about "different ethnic groups" and "immigrant

6 Mörsch, "Application," p. 200.
7 Carmen Mörsch, *Die Bildung der A_n_d_e_r_e_n durch Kunst*. Vienna: Zaglossus, 2019.
8 For example, Chandra Talpade Mohanty, "Under Western Eyes: Feminist Scholarship and Colonial Discourses," *boundary 2*, vol. 12, no. 3 –vol. 13, no. 1 (1984): On Humanism and the University I: The Discourse of Humanism, pp. 333–58.

backgrounds" rather than racialized bodies, which is what issues of representation are really about. I also affirm, at least on the level of language, concepts such as "cultural diversity" or "social inclusion" without reflecting more deeply on their power effects.[9]

As may have become clear by now, the fundamental difference between the concept of discrimination critique and concepts such as diversity, plurality, inclusion, or integration is that the focus is first and foremost on one's own position in social space, as well as on the power effects and potential for discrimination resulting from this position. The "willingness to change," one of Steyn's indicators, is articulated here, for example, in the concrete question of what needs to change in existing structures concerning the distribution of resources and behaviors so that people from underrepresented social groups can and want to be active in a particular setting.

Thus, it is not only my analytical considerations from 2005, but also my proposals for a changed practice that would have to be extended in a discrimination-critical, intersectional manner. From this perspective, a deeper and clearer appreciation of the students' resistance would be necessary: their play with the entrance stickers would have to be elaborated as a form of subversion triggered by the interaction of their bodies, which are othered in the exhibition space and in the education system. It was made possible because, on the one hand, the students disregarded the institution's hegemonic address and because, on the other hand, the situation provoked complicity, a solidarity between the various marginalized positions against the inscribed relations of power and order. This implies that, through the game, the students (and their accomplices) not only critically appropriated the exhibition, but first and foremost the critical project of the Enlightenment itself, which relies primarily on cognition and analytical observation—the latter also being represented by the worksheet of my colleague, the critical artist-educator.

These considerations could give rise to proposals as to how the thematization of power relations, which are reflected not only in art and institutional spaces but also in critical art education itself, could become the subject of educational work and its representation; with

9 Accordingly, in the German translation of the text, which appeared in 2017, a critical commentary precedes the text, and the respective terms are marked in gray.

methods that decenter the almost total dominance of cognitive-
analytical approaches in critical projects. In my view, an inescapable
prerequisite is that the intersectional composition of the artist-educa-
tors does not replicate relations of dominance but corresponds to the
composition of the groups of young people they work with. This, in
turn, ultimately implies working on the mechanisms of structural
exclusion and social reproduction in the professional fields of art and
education.

The demand for discrimination-critical work at the interface of edu-
cation and art is thus radical in the literal sense of the word:
discrimination critique attacks this interface at its roots, questioning
and changing its content, its methods, and its structures. This is
accompanied by great resistance and irresolvable contradictions.
Nevertheless, or rather precisely because of this, I consider it abso-
lutely necessary in order to interrupt historically developed power
relations that are still constitutive today—in a field of work whose
self-narrative ultimately claims to be wholly educational, liberating,
and empowering.

rather than

In revising a fifteen-year-old text, I wanted not least to illustrate one of the ways of working that emerge from a discrimination-critical perspective: constant loops of reflection concerning one's own actions. I was happy to take the time to do so in this context. Speaking of time, a paradox that is decisive for a discrimination-critical practice appears at the end of this text: it requires time, which, at the same time, is not available. Not because the conditions of production don't allow for time—in my opinion, this serves mostly as an argument for the preservation of power relations—but rather because the concerns associated with discrimination critique are so urgent that it is a privilege to be able to take one's time with them.

Translated from the German by Kevin Kennedy

+ Daniel Neugebauer is head of the Department of Communications and Cultural Education at Haus der Kulturen der Welt. Educated as a literary scholar, he is interested in the interfaces of communication and educational work. Having trained at the Kunsthalle Bielefeld, from 2012 to 2018 he headed the division of marketing, mediation, and fundraising at the Van Abbemuseum in the Netherlands. In 2016/17 he coordinated marketing for documenta 14 in Kassel and Athens. In recent years, inclusion and queering have been the focus of his institutional practice.

+ **Maaike Bleeker** is Professor of Theatre Studies at Utrecht University and head of the Department of Media & Culture Studies. In her work, she combines approaches from the arts and performance with insights from philosophy, media theory, and cognitive science. She is PI of the research project "Acting Like a Robot: Theatre as Testbed for the Robot Revolution." Her monograph *Visuality in the Theatre* was published in 2008. She (co)edited several volumes including *Anatomy Live: Performance and the Operating Theatre* (2008), *Transmission in Motion: The Technologizing of Dance* (2016), and *Thinking Through Theatre and Performance* (2019).

+ **Carmen Mörsch** teaches and researches in art didactics at the Kunsthochschule Mainz, Johannes Gutenberg University. She does this from a queer-feminist, postcolonial and discrimination-critical perspective. She is a member of the Research Training Group "Educational Processes in Discrimination-Critical University Teaching," the network "Another Roadmap for Arts Education" https://another-roadmap.net, and the collective e-a-r, education and arts research http://e-a-r.net.

+ **Zeyno Pekünlü** runs the Work and Research Program of the Istanbul Biennial for young artists and researchers. She is part of the editorial board of e-journal *Red Thread* and member of the Institute of Radical Imagination. Scanning a range of issues, from the construction of maleness and femaleness as gender roles to questioning knowledge and its distribution, her work aims to decipher "power" that encompasses the intimate and the social simultaneously. She recently participated in L'Internationale's *Artists in Quarantine* (2020).

+ Eliza Steinbock, since September 2021 Associate Professor in Gender and Diversity Studies at Maastricht University, is author of the award-winning book *Shimmering Images: Trans Cinema, Embodiment, and the Aesthetics of Change* (2019) and co-editor of *Art and Activism in the Age of Systemic Crisis: Aesthetic Resilience* (2020). Eliza is currently project leader of The Critical Visitor consortium, developing intersectional approaches for inclusive heritage (2020–25). Together with Susan Stryker, Eliza co-edits the Duke University Press book series ASTERISK*: Gender, Trans-, and All That Comes After.*

<center>Colophon</center>

Das Neue Alphabet (The New Alphabet) is a publication series by HKW (Haus der Kulturen der Welt).

The series is part of the HKW project *Das Neue Alphabet* (2019–2022), supported by the Federal Government Commissioner for Culture and the Media due to a ruling of the German Bundestag.

Series Editors: Detlef Diederichsen, Anselm Franke, Katrin Klingan, Daniel Neugebauer, Bernd Scherer
Project Management: Philipp Albers
Managing Editor: Martin Hager
Copy-Editing: Mandi Gomez, Hannah Sarid de Mowbray
Design Concept: Olaf Nicolai with Malin Gewinner, Hannes Drißner

Vol. 10: *Re_Visioning Bodies*
Editor: Daniel Neugebauer
Coordination: Laida Hadel
Contributors: Maaike Bleeker, Carmen Mörsch, Zeyno Pekünlü, Eliza Steinbock
Translations: Kevin Kennedy
Graphic Design: Malin Gewinner, Hannes Drißner, Markus Dreßen
DNA-Lettering (Cover): Carla Selva
Type-Setting: Hannah Witte
Fonts: FK Raster (Florian Karsten), Suisse BP Int'l (Ian Party) Lyon Text (Kai Bernau)
Image Editing: ScanColor Reprostudio GmbH, Leipzig
Printing and Binding: Gutenberg Beuys Feindruckerei GmbH, Langenhagen

Image credits:
p. 6 Collection of the United States Holocaust Memorial Museum, courtesy of National Archives and Records Administration, College Park
p. 17 From the personal collection of an anonymous individual present at the event, Lili Elbe Archive, Berlin
p. 19 Collection of Individual Photos, Lili Elbe Archive, Berlin
p. 22 Dana International Collection, Lili Elbe Archive, Berlin
p. 25 Gert-Christian Südel Collection, Lili Elbe Archive, Berlin
pp. 43 – 57 © Zeyno Pekünlü
pp. 59 – 64 © Carmen Mörsch; originally printed in Carmen Mörsch, „Application: Proposal for a Youth Project Dealing with Forms of Youth Visibility in Galleries", in: Anna Harding (ed.), *magic moments: collaboration between artists and young people*, London: Black Dog Publishing, pp. 198–205

Published by:
Spector Books
Harkortstr. 10
01407 Leipzig
www.spectorbooks.com

Distribution:
Germany, Austria: GVA Gemeinsame Verlagsauslieferung
 Göttingen GmbH & Co. KG, www.gva-verlage.de
Switzerland: AVA Verlagsauslieferung AG, www.ava.ch
France, Belgium: Interart Paris, www.interart.fr
UK: Central Books Ltd, www.centralbooks.com
USA, Canada, Central and South America, Africa:
 ARTBOOK | D.A.P. www.artbook.com
Japan: twelvebooks, www.twelve-books.com
South Korea: The Book Society, www.thebooksociety.org
Australia, New Zealand: Perimeter Distribution,
 www.perimeterdistribution.com

Haus der Kulturen der Welt
John-Foster-Dulles-Allee 10
D-10557 Berlin
www.hkw.de

Haus der Kulturen der Welt

Haus der Kulturen der Welt is a business division of Kultur-
veranstaltungen des Bundes in Berlin GmbH (KBB).

Director: Bernd Scherer
Managing Director: Charlotte Sieben
Chairwoman of the Supervisory Board: Federal
 Government Commissioner for Culture and the Media
 Prof. Monika Grütters MdB

Haus der Kulturen der Welt is supported by

Minister of State for Culture and the Media

NEU START KULTUR

Federal Foreign Office

First Edition
Printed in Germany
ISBN: 978-3-95905-496-6

Recently published:
vol. 1: *The New Alphabet*
vol. 2: *Listen to Lists*
vol. 3: *Counter_Readings of the Body*
vol. 4: *Echo*
vol. 5: *Skin and Code*
vol. 6: *Carrier Bag Fiction*
vol. 7: *Making*
vol. 8: *Looking at Music*
vol. 9: *A Kind of World War*
vol. 10: *Re_Visioning Bodies*

Forthcoming:
vol. 11: *What Is Life?*
vol. 12: *On Image Systems*
vol. 13: *Artificial Music*
vol. 14: *Archives & Utopia*